THE LAST
GOODBYE

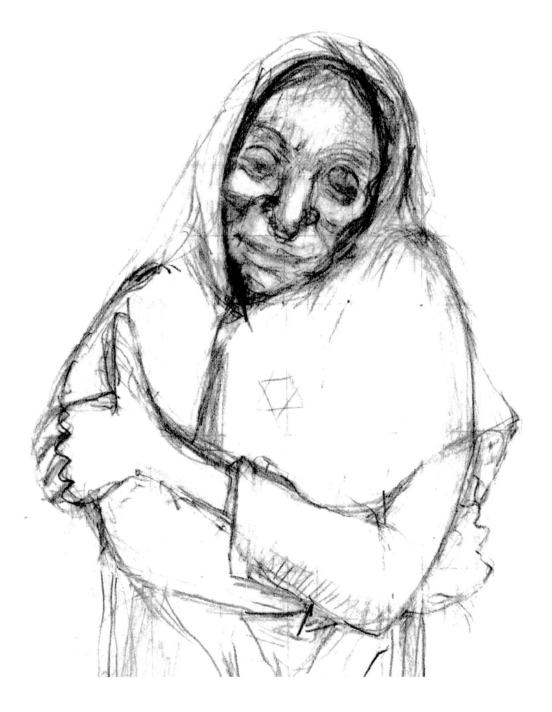

Published by Memoirs

MEMOIRS
PUBLISHING

Memoirs Books
25 Market Place, Cirencester, Gloucestershire, GL7 2NX
info@memoirsbooks.co.uk www.memoirspublishing.com

ISBN 978-1-908223-87-6

Also by Edith Hofmann

Unshed Tears: A Novel ... But Not A Fiction

Printed in England

TO MY PARENTS
AND
ALL THE CHILDREN
WHO DID NOT COME BACK

THE LAST
GOODBYE

EDITH HOFMANN

I am a survivor of the Holocaust. I was born in Prague in 1927. In 1941 my parents and I were deported to the Lodz Ghetto where within a year both my parents had died and I was left to fend for myself.

In the summer of 1944, with the Russians advancing, the whole Ghetto population was herded into cattle trucks and sent to Auschwitz. For the majority it was their final journey. A small group of us were selected for work. With our hair shaved off and deprived of all our possessions, we travelled to Kristianstadt, a labour camp in Silesia to work in an underground munition factory.

In January 1945, with the Russians approaching again, we set off on a Death March across snow-covered Germany to Bavaria. There cattle trucks were waiting for us. Spending a week in crowded conditions without food or water we arrived in Bergen Belsen on 15th March. A month later we were liberated.

Back in Prague, the moment I had dreamed of welcomed me with the devastating news that none of my family and friends would ever return. I bought an exercise book and started recording in detail all that I had experienced and witnessed during the previous five years. I was going to write a book. I owed it to all those who didn't make it back.

In 1946, I came to England, studied and became a teacher. As soon as I could express myself in English, with the help of my notes, I embarked on writing the book. It describes the war years as seen through the eyes of an adolescent girl. I decided to write it as a novel because I was too scared of German retribution should I write it as an autobiography.

Sadly, the publishers didn't want to know, dismissing it as not being commercial because people had had enough of war and didn't want to read about it. Eventually, however, with renewed interest in the Holocaust, it was published in 2001 under the title of **Unshed Tears** under my maiden name of Edith Hofmann.

While the script was gathering dust, the memories of the squalor of the Ghetto, the chimneys and red skies of Auschwitz, the struggle through the snow of the Death March and walking corpses of Belsen never left me.

In the 1970s, while doing an A level course in History of Modern Art, it suddenly came to me that I could interpret those vivid memories in a visual way. I joined a class in fine art and learned to paint. Eventually, after a course of modern painting, I evolved a pictorial language, that enabled me to put my visions on canvas. It wasn't so much cruelty or physical suffering that I wanted to record. Most of all, I wanted to show what it felt like to be a human being in the starved, emaciated, strange looking body, forever being separated from loved ones.

How many people stop to think that the six million dead were individual human beings with dreams of their own, each with a story to tell, each wanting to live? This is why in my paintings are depicted in different colours. The 30 paintings may seem bizarre but they represent bizarre situations and illustrate the most deeply felt incidents from my book. The red skies in many of them symbolise the skies of Auschwitz which always seemed to be red.

In recent years I have been writing poems to accompany the pictures, in which I attempt to speak for the tortured souls of the victims – let them cry out to us.

Edith Birkin

Edith Birkin (née Hofmann)

The paintings have been exhibited at:

Coventry Cathedral 1984

With the Anne Frank exhibition in Manchester 1987

The Ben Uri Art Society, London 1989

With the Wiesenthal Exhibition, London 1990

The University of Brighton Gallery 1994

Birmingham City Museum and Art Gallery 1995

Terezin Memorial Museum, Czech Republic 1996-1997

Beth Shalom Holocaust Memorial Centre, Laxton 1997-2001

Courtyard Theatre Gallery, Hereford 2005

In conjunction with the Anne Frank exhibition, Hereford 2005

ENTRY INTO THE GHETTO

Through the dark the ghosts of humanity
stood staring with sunken eyes
that beamed the suffering of centuries gone past.
What strange world was this,
that charged us with foreboding
as we plodded along the cobbled streets?
What strange beings outside their hovels
looked with bewilderment at another humanity,
that was us?

So this was the Ghetto.
Poverty silhouetted against the sky,
the smell of rotting waste
nodding their eerie welcome,
as silently with fearful hearts
we crossed the threshold to our
new beginning.

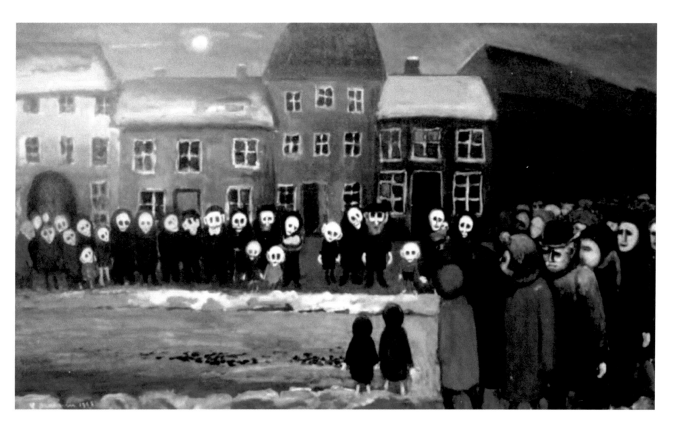

LODZ GHETTO, 1941

FIRST DAY IN THE GHETTO

With fear tearing at my heart
I eyed the withered creatures
that with unseeing eyes and shuffling feet,
cowering in a world of their own
progressed to their destination.

Were they real people once
in a world where flowers grew
and tables laden with food
called the healthy family to feasts,
where laughter and beauty reigned?

I knew that fate,
having dealt them this cruel blow
stood waiting with outstretched arms
ready to devour us, too.

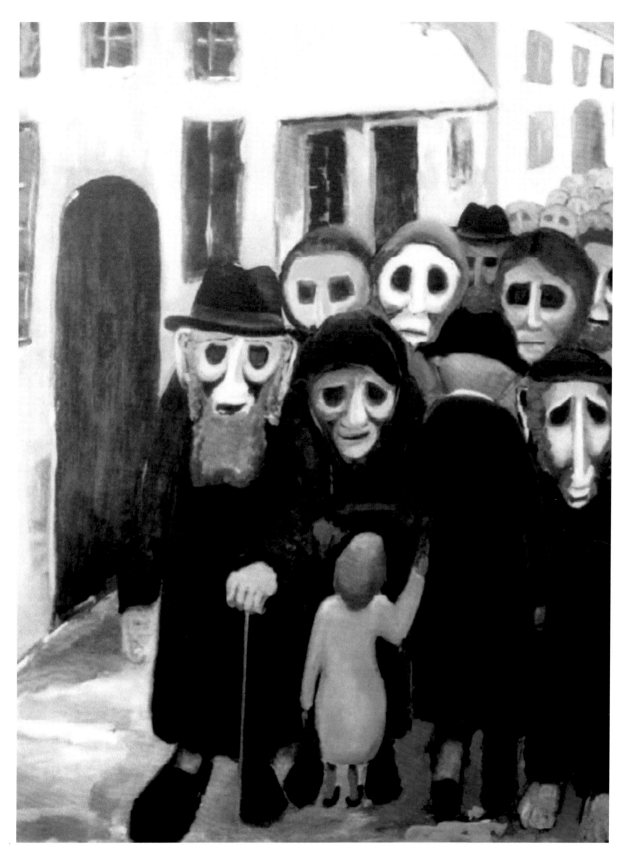

LODZ GHETTO, 1941

WASTE DISPOSAL, LODZ GHETTO

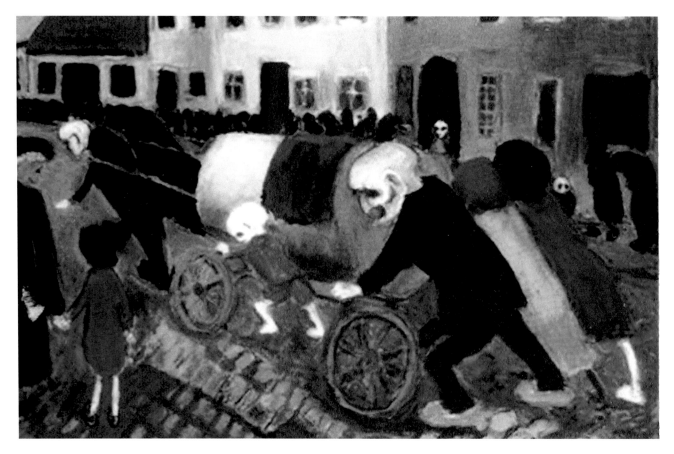

LODZ GHETTO, 1942

GHETTO MAN

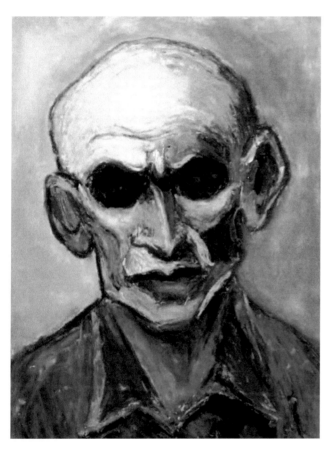

LODZ GHETTO, 1941

GHETTO WOMAN

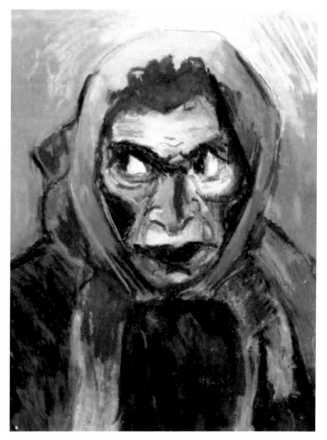

LODZ GHETTO, 1941

DON'T TAKE MY CHILD

All the devils in this world broke loose
and from a thunder cloud descended into the Ghetto.
With cunning leers they crept into the inviting minds
of our baby snatchers,
and caused a storm of horror and agony
that cruellest nightmares are made of.
There was no waking up.

In a whirlwind of sadism, grinning with pleasure,
the German soldiers tore the crying children from our arms
and pleased with a job well done,
carried them to their final destination.
Our arms ached for their warmth,
and our battered minds screamed
with untold despair.

With unseeing eyes we gazed at the scene that was no more.
The quiet Ghetto wept for generations gone and lost forever,
their innocence and laughter turning into memories
for years that lay ahead.
With turmoil in our hearts, fifty years hence we ask,
"Why? … Where are you now?
Come back to us."

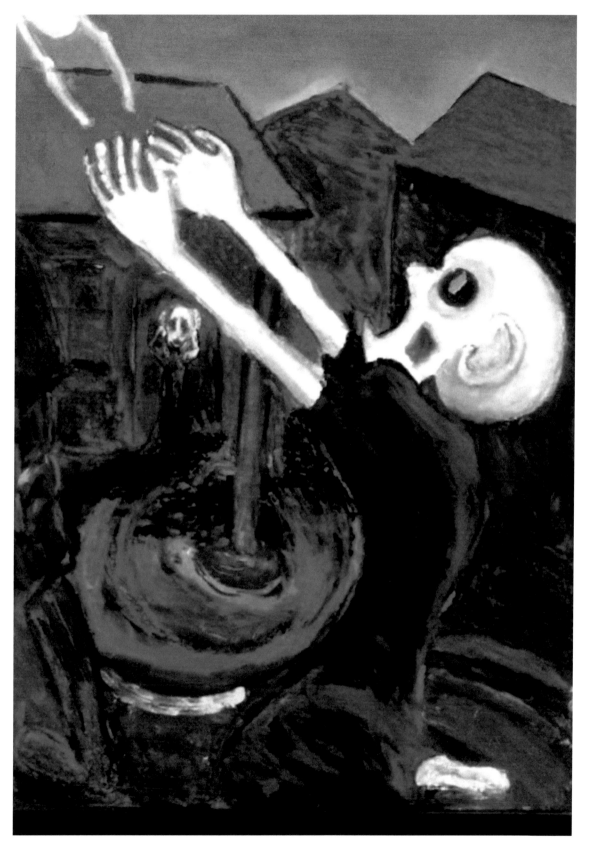

LODZ GHETTO, 1942

THEY TOOK MY CHILD

This morning I had a child and now he is no more.
From my womb he came and lay in my arms,
I fought but lost.

They hit me, the butt of the rifle severing our grasp,
then numbing my face - never mind my teeth,
there is no food to chew anyway,
they snatched him away.

He lay in his cradle once, with toys, gurgling,
laughing happily.
This morning he sat on my knee, I told him a story
and he laughed, too.

Then he was gone – just like that,
only the screams remained,
the laughter that echoed through the streets
was the Germans'.

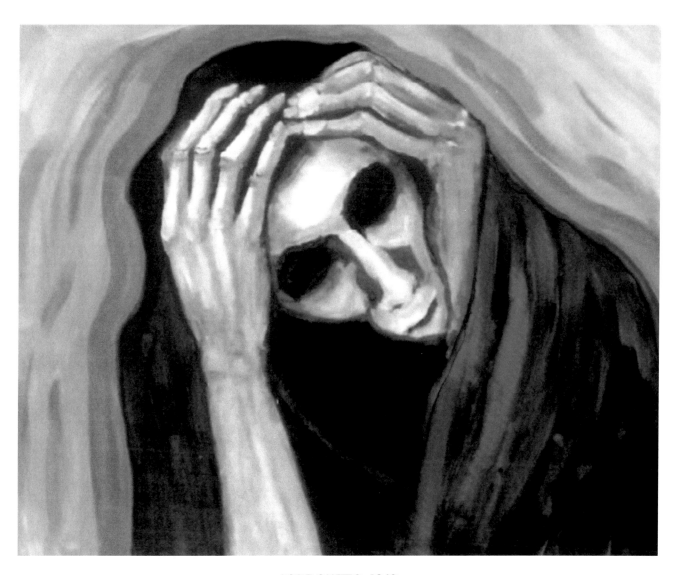

LODZ GHETTO, 1942

THE SICK MOTHER

His silent prayer filled the room
as an eternal loneliness
beckoned its viscous head.
The room once filled with family warmth,
laughter and love diminished in size
as one after another succumbed to death.

A dismal grayness remained
as heavy hearts of mother and son
consoled each other in tight embrace.
The arms once attempting to keep him safe
lay lifeless, white and thin in bed.
God, please don't take her, too.

Who will hold me when I am sick,
sing me to sleep and tell me about the
magical world outside,
show me the moon that shines on us all?
How will I manage in the ghetto alone?
I will be good, please God, let her live.

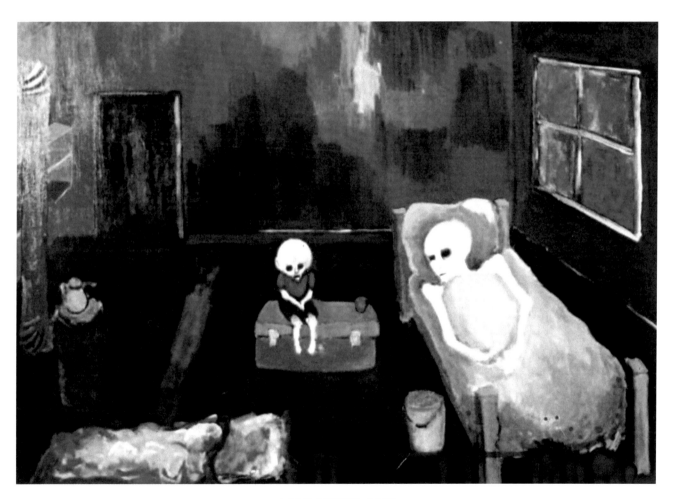

LODZ GHETTO, 1942

THE DEPORTATION OF CHILDREN

The silent Ghetto waited
as the streets lay bare under the threat of curfew.
"Stay in your homes", it read, "or be shot."
Days of foreboding, hunger and cold chilled our hearts as we waited.
"What happens next?" we asked.

The clatter of lorries, the thunder of boots,
the roar of voices told all.
"Send down your children!
Send all under ten!
All under ten down now!"
"Bring down your babies,
"Quick! quick! at once!"

The jackboots rumbled up the stairs,
kicked open the rotting doors.
A commotion of commands, sadistic laughter,
begging and pleading, crying of children,
desperate screams, and wailing of men,
pandemonium filled the air.

What chance did the weak, starved creatures have
against the pleasure seeking giants,
waving their weapons with unchecked fury,
grinning triumphantly, the job well done.
The half crazed mothers, terrified children,
the furious battle raged on.

The grasp of mothers and child was strong,
filling the courtyard, holding on…
The kick of a boot, the butt of a rifle
severed the grip, the kidnappers won.
"Scream if you like, tear out your hair,
more fun for us."
Then they were gone.

They took our children and laughed

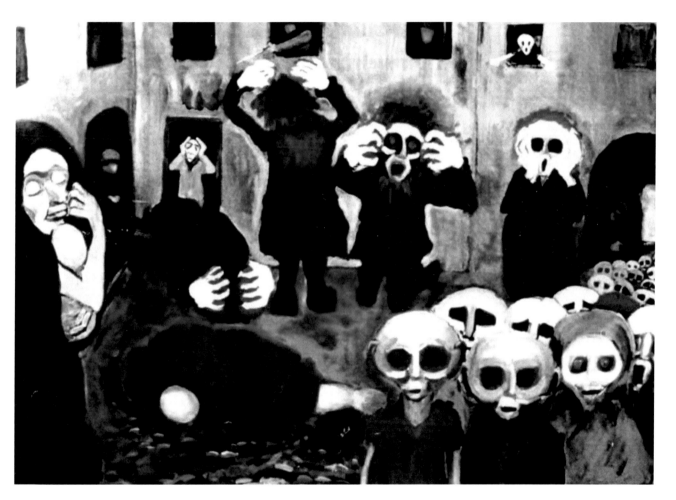

LODZ GHETTO, 1942

PRAYING FOR THE DEAD

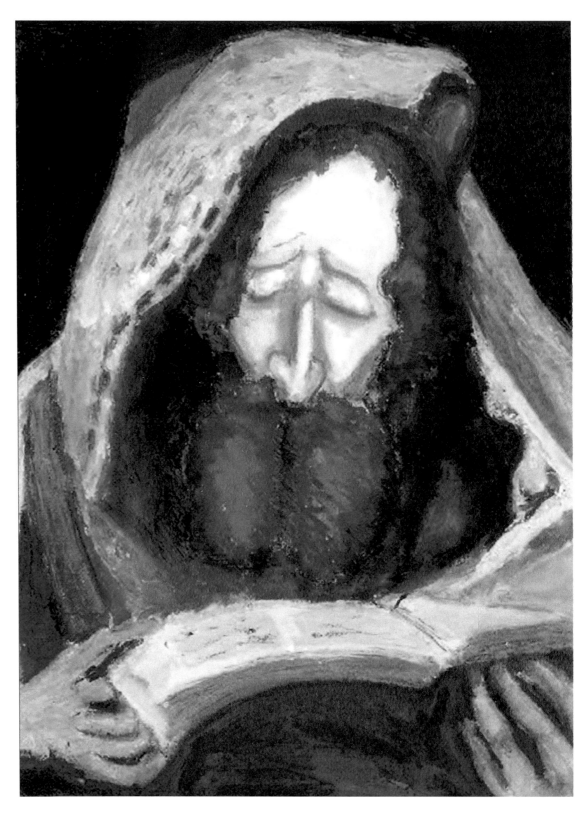

LODZ GHETTO, 1941 - 1944

SAVE US O'LORD!

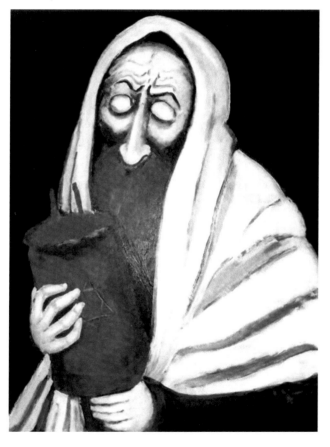

LODZ GHETTO, 1941 - 1944

WHERE ARE YOU GOD?

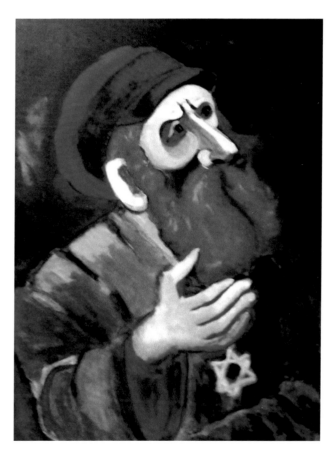

LODZ GHETTO, 1941 - 1944

THE FINAL JOURNEY
TO AUSCHWITZ

"Another place, another town,"
the Germans promised."
"With better houses, abundance of work
to help feed our shrivelled bodies."
But then we had no choice.

Our hopes of freedom shattered,
as advancing Russian troops stopped close,
and coming down to earth
we volunteered to go.
"Better the devil you know," we argued
but then we didn't have a choice.

The rickety cattle train rattled from Lodz
from years of misery and death,
toward another world - of Auschwitz.
And filling our hearts with optimism, there
in the dark box we lifted our heads
and agreed, "It couldn't be any worse."

Auschwitz beckoned.

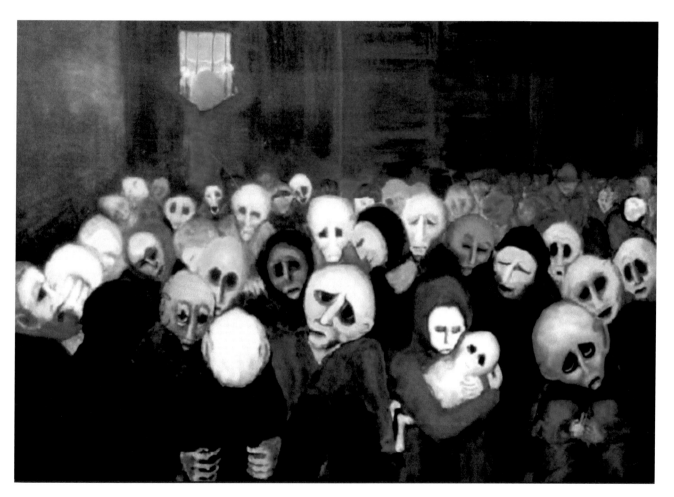

TO AUSCHWITZ, 1944

SELECTION

Left! Right! Here! There!
The finger of destiny decided our fate.
The hysteria and screams of separation,
quashed by mad dogs,whips and guns,
excited figures with wild eyes and fat necks
bulging out of well pressed uniforms,
echoed along the Auschwitz ramp.

And then
as we stood in rows,
under the strange red skies,
and belching smoke,
waiting,
silently said our farewells.

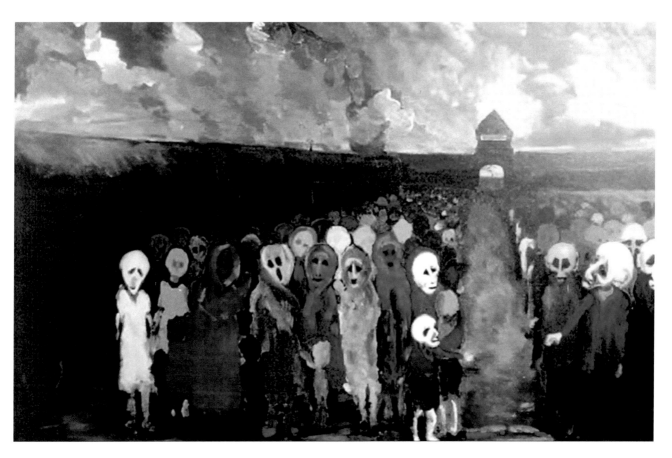

AUSCHWITZ, 1944

WHERE HAVE ALL THE CHILDREN GONE?

Abandoned treasures scattered
under a glowing sky.
Encouraged by smiling guards,
holding hands, small boys and girls
trudged through the snow to promised
reunions with parents and toys.

New little footprints in the snow,
new toys and cases under red skies.
Trusting children are marching on
towards the chimney belching smoke.
Children following the ones before.
Ashes upon ashes.

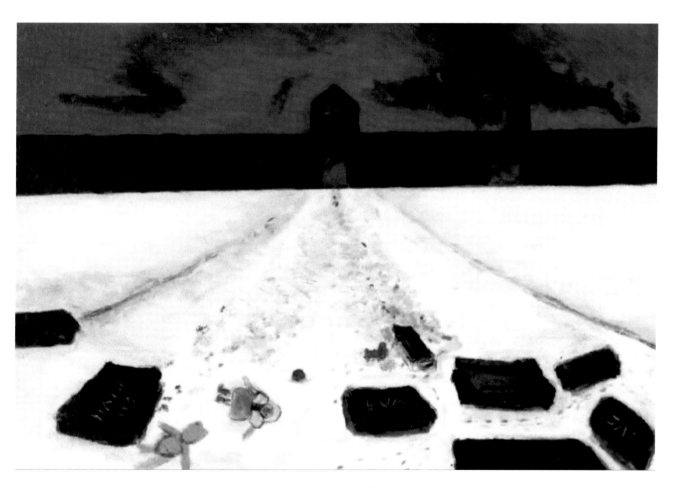

AUSCHWITZ, 1944

THE CAMP OF TWINS

Through barbed wires of their camp,
The twins - side by side, stare at the newcomers,
searching for family and friends
among the columns of the weary crowd
marching to their death.

Privileged siblings spared on an island
in the sea of horror and destruction,
getting ready for the knives and needles
of the ruthless doctors and scientists,
eager to experiment on the phenomenon of twins.

Unthinkable deeds performed, no organs spared
in search of secrets of heredity.
The ultimate goal – perfection itself,
the birth of blue eyed, blond Aryan babies,
perfect new generations for years to come.

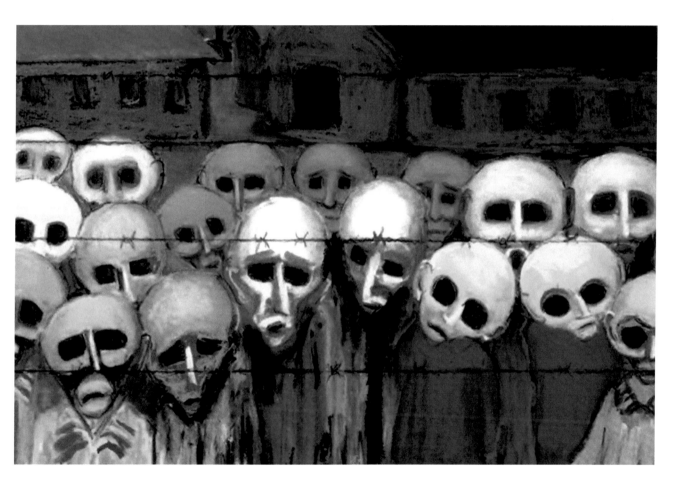

AUSCHWITZ, 1944

BE A GOOD BOY

Goodbye little man,
be a good boy,
remember your manners
and all will be well.

Don't cry little man,
be a brave boy,
do as they tell you
then all will be well.

Goodbye … little … man.

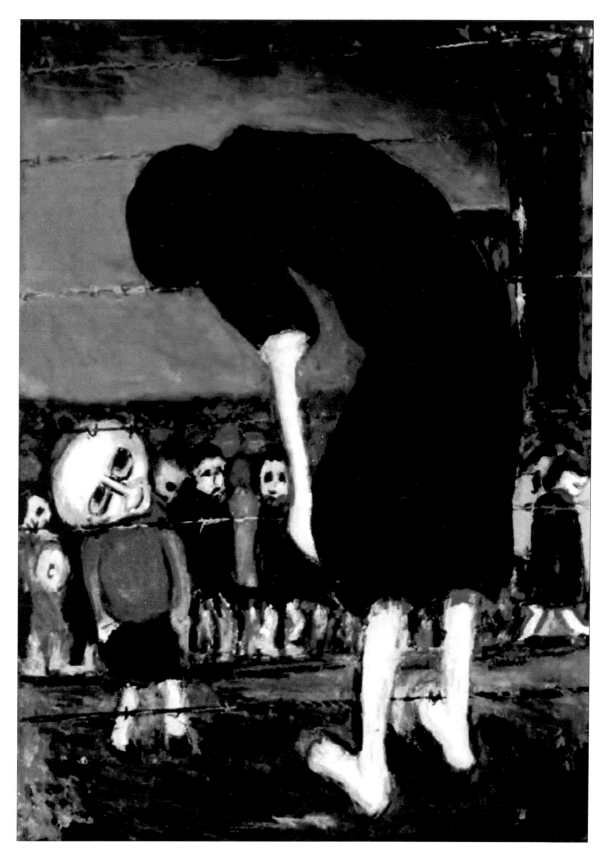

AUSCHWITZ, 1944

THE LAST SUPPER

The flames leapt high,
the smoke danced in the scarlet sky.
The chimney beckoned as unsuspecting children
devoured the tasty soup,
scraping out the last little drop
with their crooked spoons.

Soon they will be hungry no more.

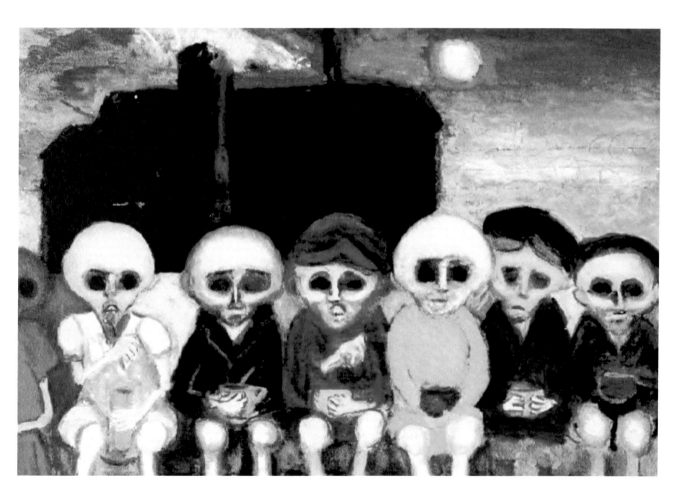

AUSCHWITZ, 1944

BORN EQUAL

When they stand there naked or in shabby clothes,
stripped of everything that money can buy,
which is the teacher, doctor or boss,
which is the plumber, beggar or lord?

Side by side – cold, dejected and weak,
deprived of freedom, craving for food,
the number on forearm instead of a name,
each one a target for the perpetrator's game.

Titles forgotten, the past is no more.

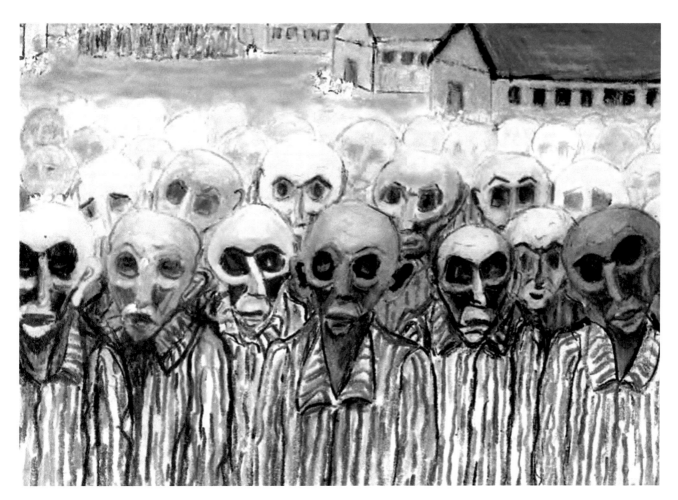

AUSCHWITZ, 1944

HE WAS MY FRIEND

In the cruellest of hells
by Lucifer's orders,
I stoked up the fires and helped
to send men on their final journey
to be devoured by flames,
and into ashes turned.

How could it be that Josef, my best friend
from times long gone,
now fresh from the gas chamber,
his face distorted is lying here,
waiting for me to do the deed,
"Farewell, my friend, farewell."

The dreams we dreamed as schoolboys
the path laid out for future years,
ambitions fulfilled.
"Forever friends" we vowed.
And today? … How could it be?
Josef, my friend forgive me.

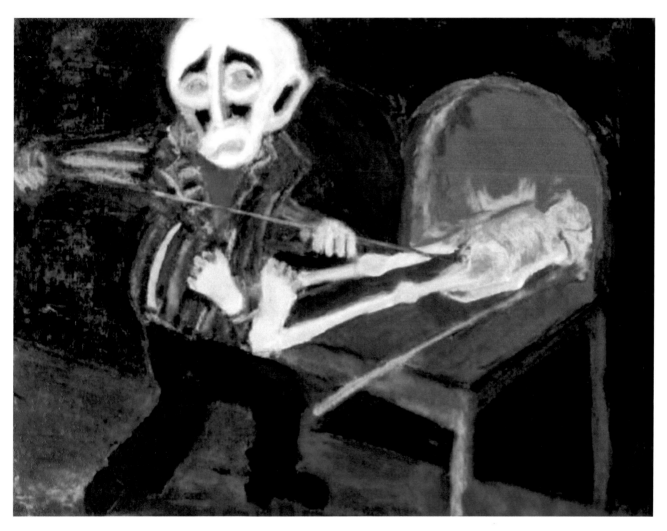

AUSCHWITZ, 1944

ANOTHER RELEASE

In his starved body and bewildered mind
he saw no future.
He cast his eyes upon the live fence
and made up his mind.
With his last bit of strength
he threw himself upon the wires and gripped them.
Sparks crackled.
For a moment his mad eyes met mine,
then he was gone.

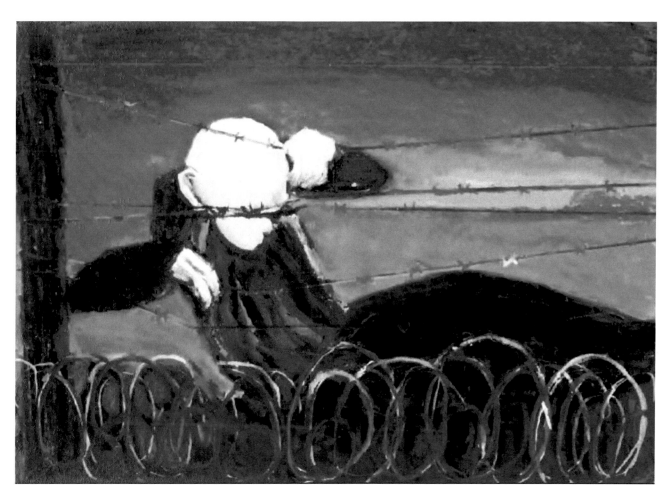

AUSCHWITZ, 1944

THE LAST GOODBYE

With her heart she embraces her weeping child.
Her arms ache to hold her one more time.
"Why is this happening?" Her silent mouth ask,
"So many partings, so many tears."

"Hurry up," her friend beckons,"We mustn't be late.
"Go now my angel, do not turn back,
We shall be united forever soon.

The smoke rises towards the red sky.
Ashes join ashes forever more.

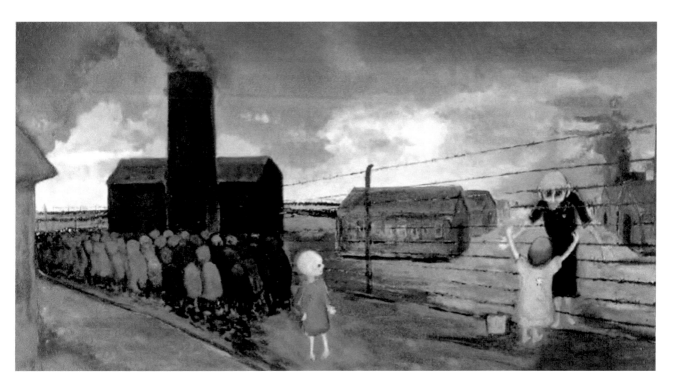

AUSCHWITZ, 1944

WHY?

Brave little lives torn from loving arms,
marching hopefully towards the belching chimney,
tender years with visions of joyful reunions
love and warmth, ambition fulfilled.

Generations of children lost to the world.
Among them great writers, musicians maybe,
a physician fighting deadly diseases,
finding a cure for ones dreaded the most
will soon go up in flames and be turned into ashes.

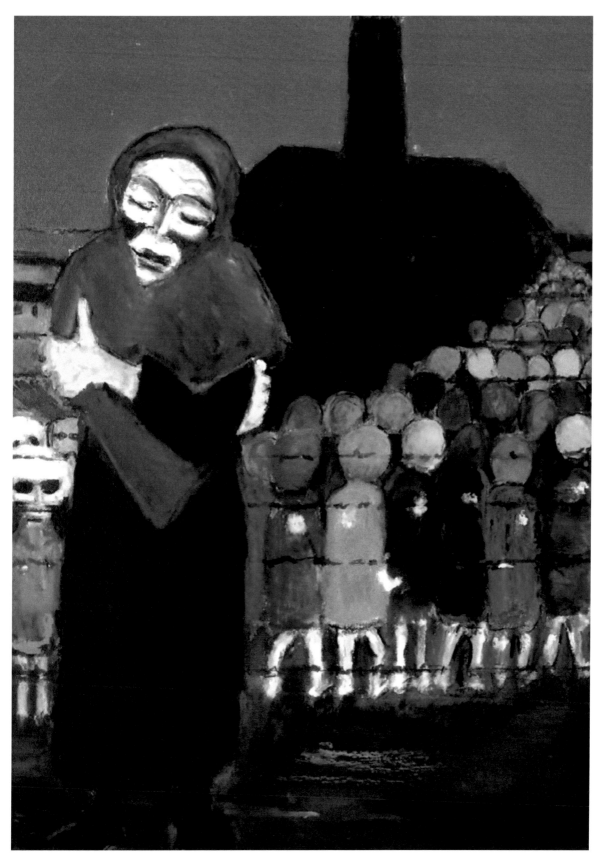

AUSCHWITZ, 1944

DRESDEN BURNING

We stood there gazing in wonderment,
As Dresden - a German city burned,
the flames reaching the sky,
a sweet revenge for the crucified souls,
for the perished innocents.
A new hope in our hearts for a speedier end
when our limbs could rest
and our gnarled bodies be restored
to dignified humanity.

We laughed with joy,
For didn't they teach their children to
throw stones as our tortured bodies
stumbled through the snow,
Death March they called it.
Didn't they teach them to spit at us
and laughed at us as skeleton-like
we struggled to push one frozen foot
in front of the other,
huddled in our shabby blankets.

They brought us here!
Pure joy! The end is near,
New strength, new hope.

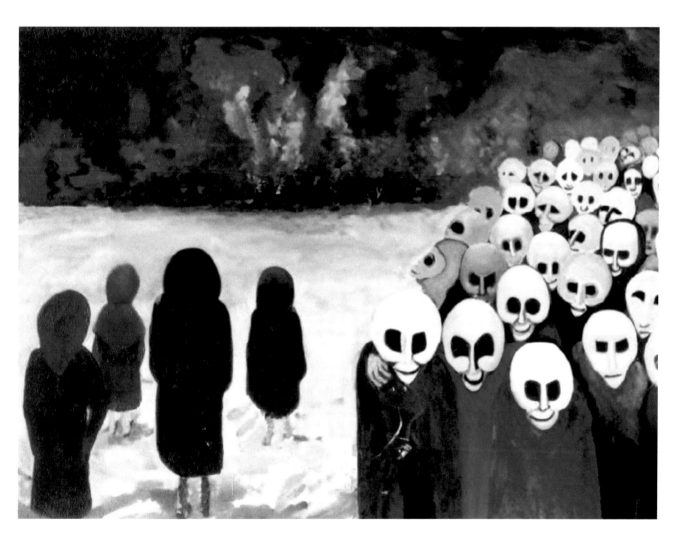

DEATH MARCH, WINTER 1945

ROLL CALL

Through the freezing cold of the early hours
to the scorching sun of day,
we waited to be counted.
Ghost like figures, having shuffled through the dark
to this ghostly meeting place.
Always five deep, a block of straight lines,
as hungry, weak, in tattered clothes,
we struggled to stay upright.

How many secrets did it hold,
then whispered to the left or right
unburdening our souls?
How many dreams we dreamed and told,
then believing they were true,
we beat a path to liberty, ate our feast,
sampled the luxury of a clean, hot bath.
Then into bed, all white and clean,
Maybe, one day…

Then an abrupt end to our deceptions,
as the well shod figure approached our rank,
eager to spot a target for his whip or gun.
Quick return to reality.
Stay upright, head up, shoulders back,
look healthy and well.
The day will come when our dreams will come true.
When? One day.
If you stand up straight.

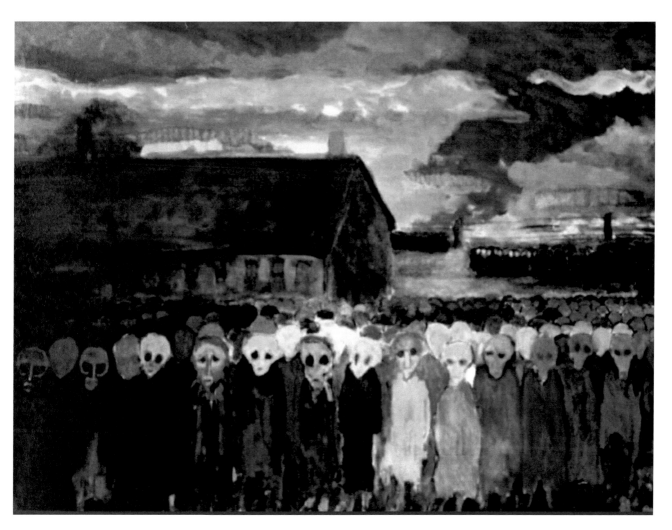

BELSEN, 1945

WHERE IS THE WORLD?

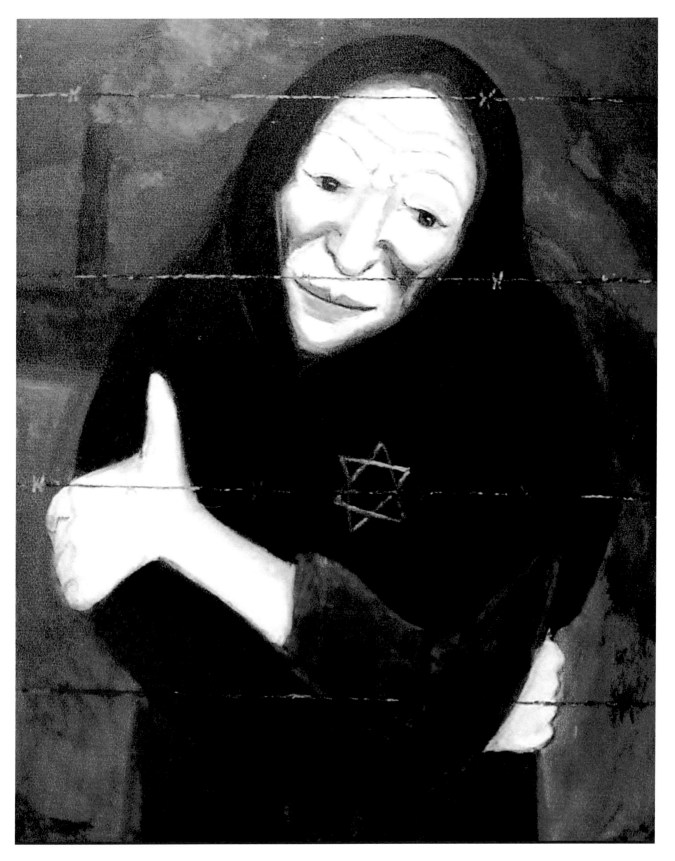

AUSCHWITZ, 1944

THE DEAD STRANGER
IN BELSEN

She died in my arms.
Last night we talked
as destiny made us neighbours
on the chilly concrete floor.
With love in her trembling voice,
she spoke of her children,
her husband, her father - a family torn apart
by the pointed finger on the ramp at Auschwitz.

Her gnarled fingers moved along an imaginary piano.
The sunken eyes in her ancient face
showed dreams
of times gone by.
She was forty, she said.
Last night she was a person, she had a name.
The heap of bones covered in rags
will soon lie in the field among the other corpses,
a name no more, a face lost to the world,
trampled over by lifeless ghosts
on their way to the latrines.

Or perhaps she will be thrown on one of the mounds
of like lost souls,
until tomorrow - when new arrivals will cover up
her withered body,
and all that will remain for us to see
will be the white sticks of bones
protruding from the heap.

Somebody's mother, somebody's wife, somebody's child.

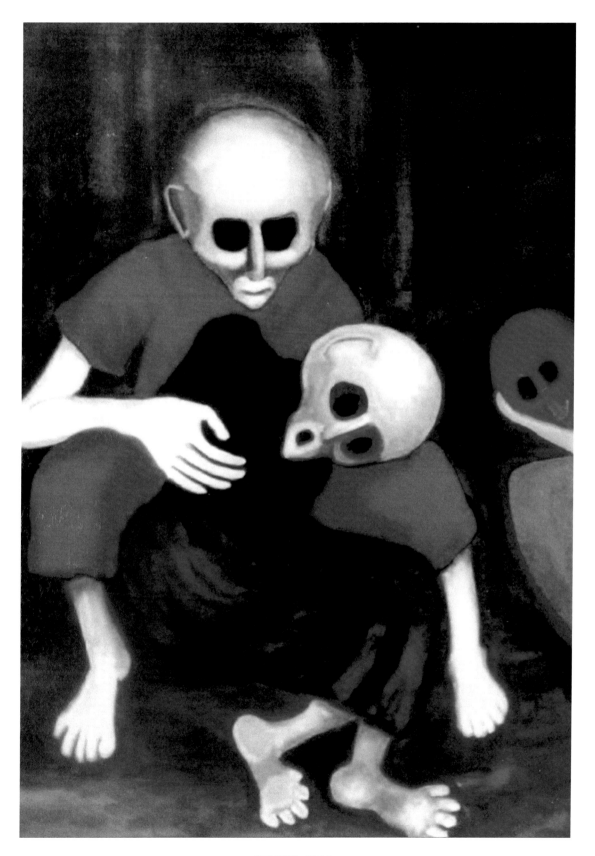

BELSEN, 1945

LIBERATION DAY

The day has come.
Four years of hoping, dreaming,
forever skirting the edge of an abyss,
that dark pit which swallowed the less fortunate ones,
holding on, one foot in front of another
towards this day of days.

When despair tugged at our soles
and our bodies cried out for one more crumb of bread,
we plodded on,
one foot in front another,
one day nearer to this glorious day.

The darkest days of slavery and horror
could not suppress the cries of hope
for when our liberators would come to free us.
We would cheer and sing and clap our hands,
and dance with unspeakable joy.

Then life would go on as before,
filled with love and warmth
and all will be well.

The day has come…

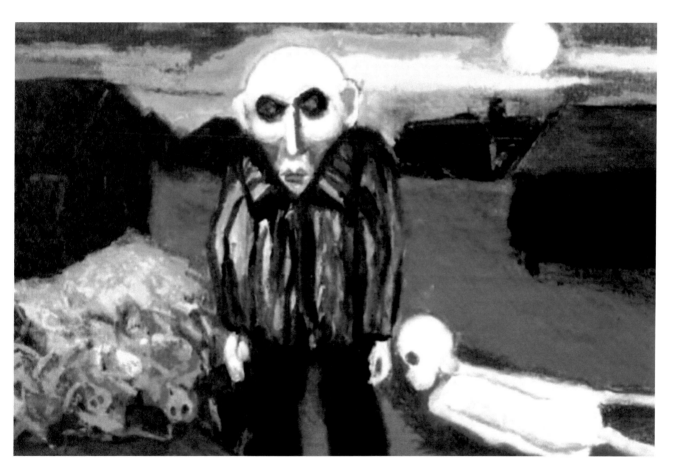

BELSEN, APRIL 1945

ARBEIT MACHT FREI
WORK SETS YOU FREE

The sticks that have been arms and legs
twisting in all directions,
eyes at bottom of deep caverns
gaze unseeingly to all corners of the camp.
They were real people once.
The day they dreamed of has arrived -
called,
"Liberation Day".

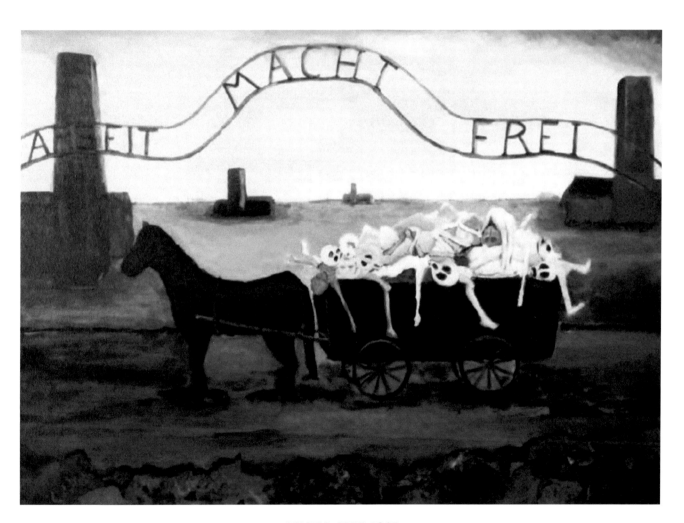

BELSEN, APRIL 1945

THE HOMECOMING 1

The bells rang for me, I thought
as I entered town,
for I was free, free, free!
After four years of a mad prison,
gloom, death and hope
I sped towards my home
carrying flowers gathered on the way,
one for each person I loved.

I opened the door
and there was no one there.
I dropped the flowers on imaginary graves
and stood silently,
knowing that the bells tolled for me.

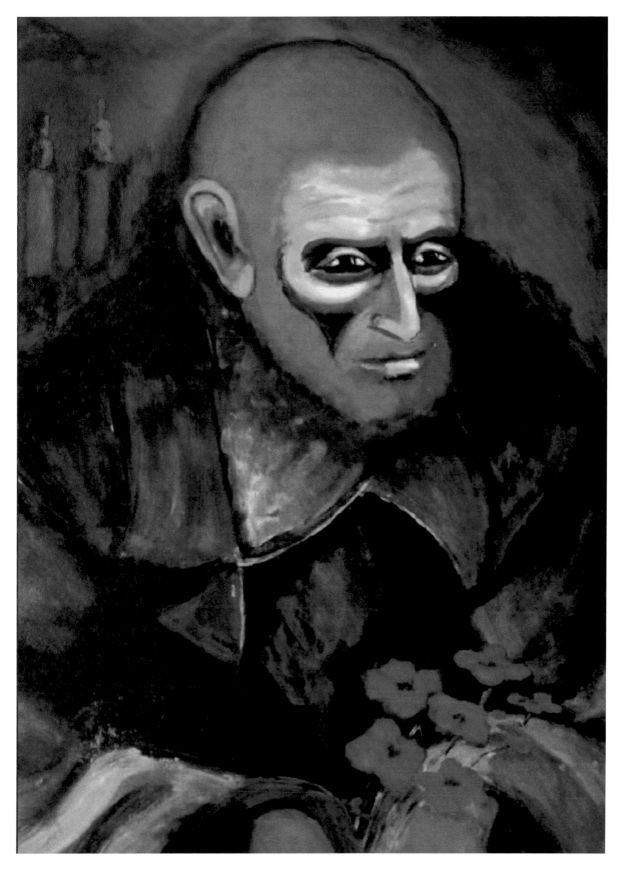

1945

THE HOMECOMING 2

It was the happiest day of my life
I thought,
as I was going home.
The dream I had dreamed through waking nights,
shivering at roll call,
the dreams of homecoming,
open arms and love,
were but a street away.
I entered.

The emptiness was crowding all around me,
the deafening silence was screaming
from all corners of the room.
"So that's it," I thought
getting the message.
The barbed wires of reality
entwined themselves around my soul,
to make me a prisoner for ever.

This time there will be no escape.

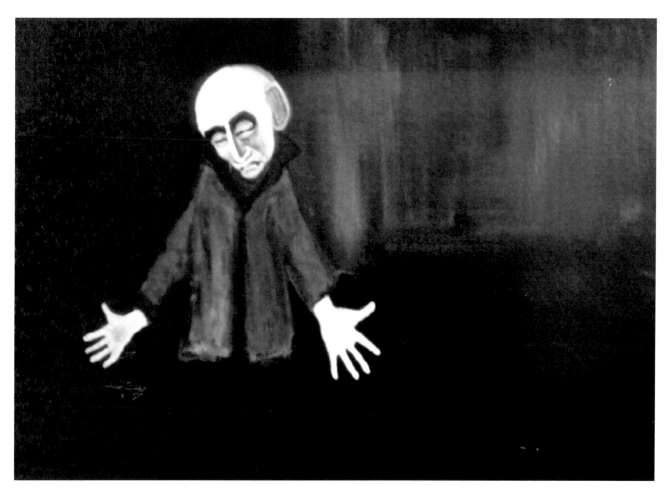

1945